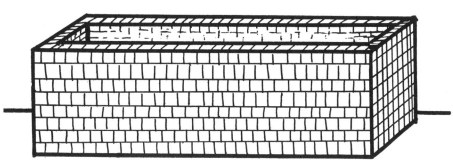

On June 13, 2005
three ice structures of various shapes and sizes
were built in front of Basel exhibition centre,
on the roof of the car park opposite,
and in the arcades of the Kunstmuseum Basel.
They were left to melt.

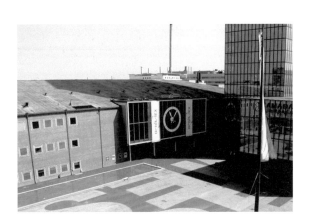

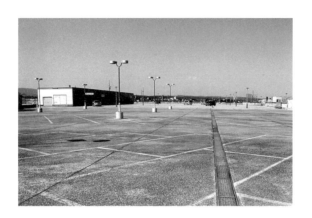

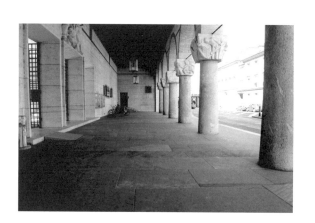

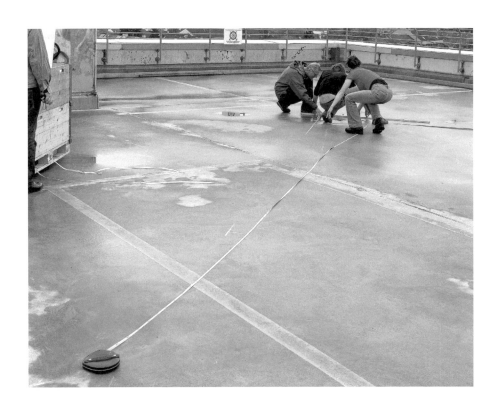

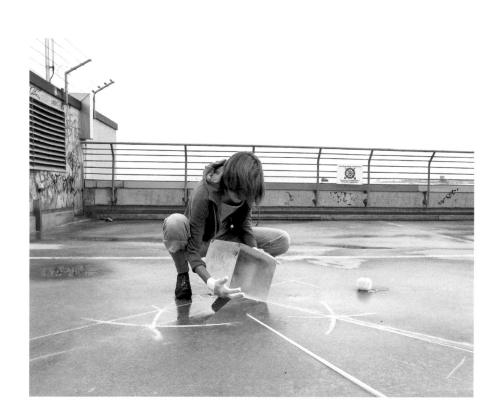

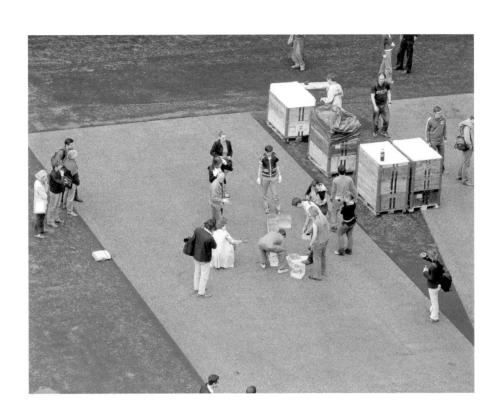

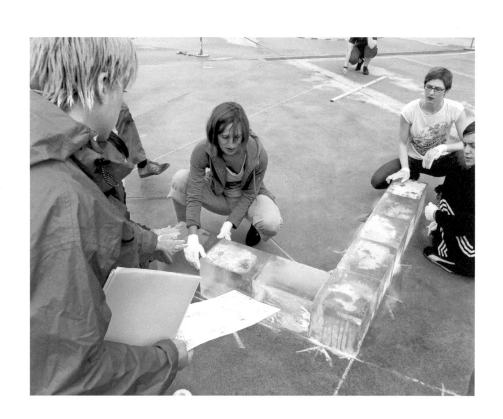

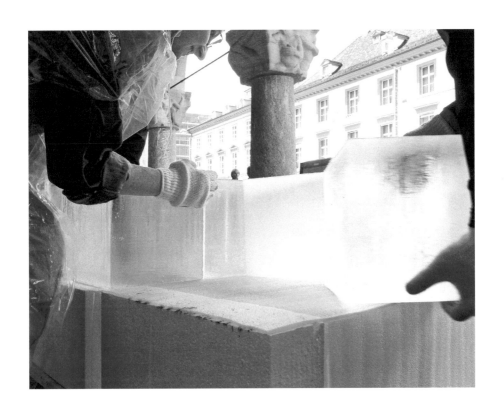

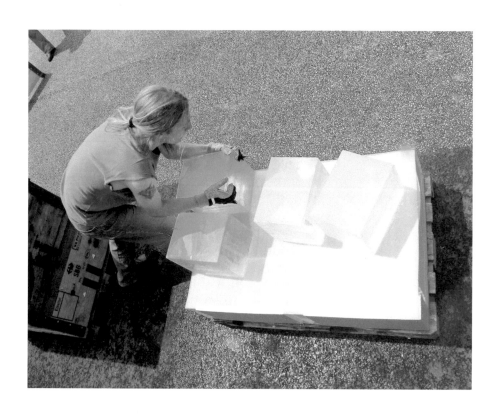

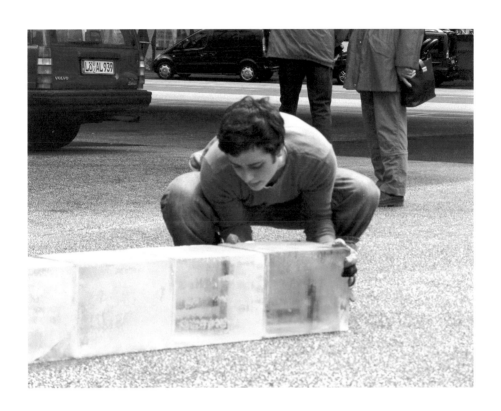

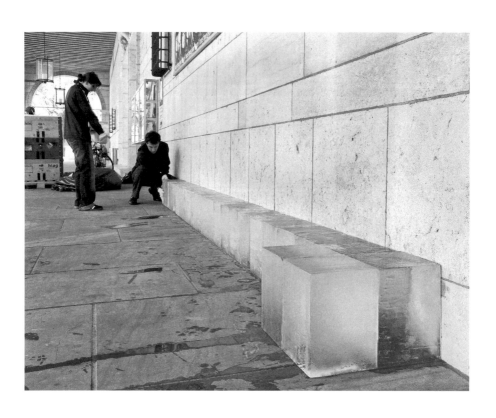

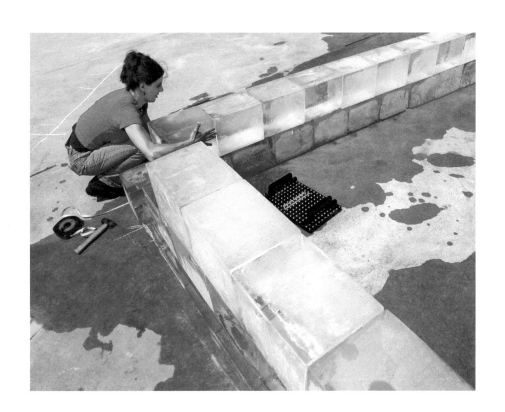

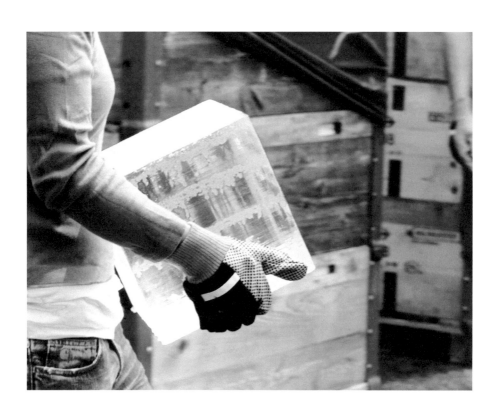

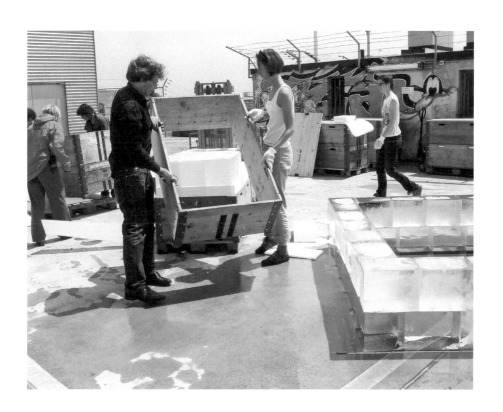

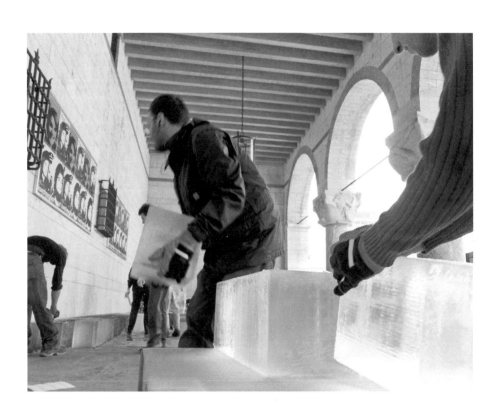

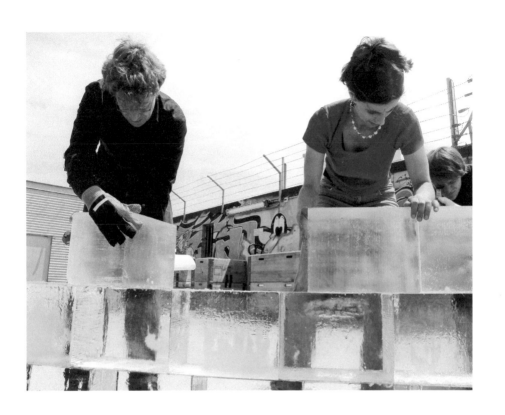

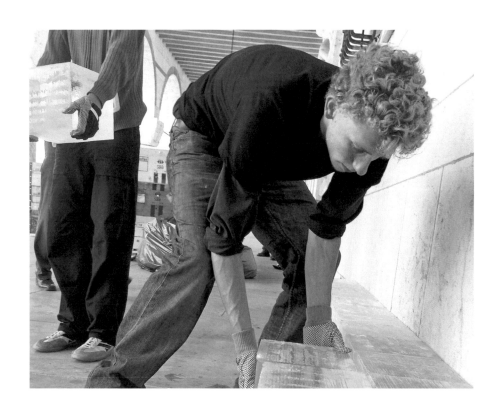

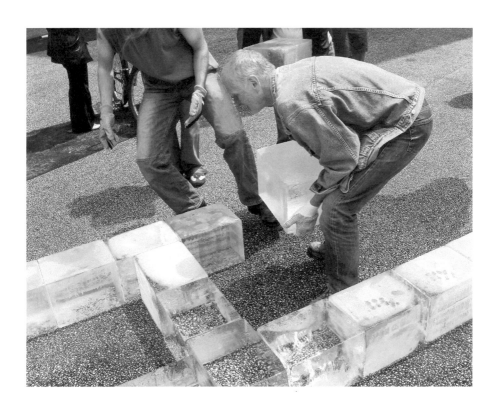

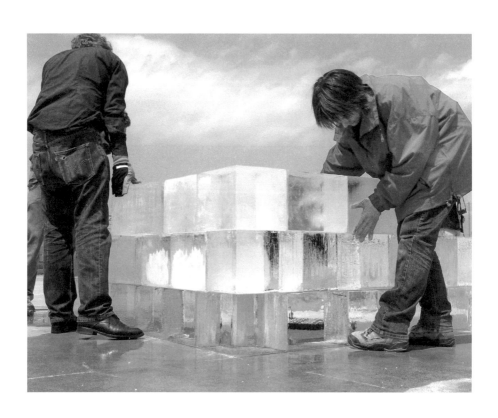

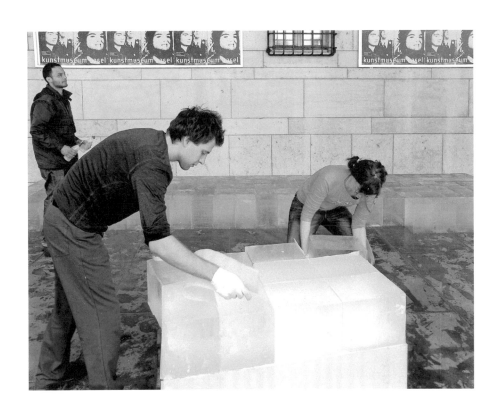

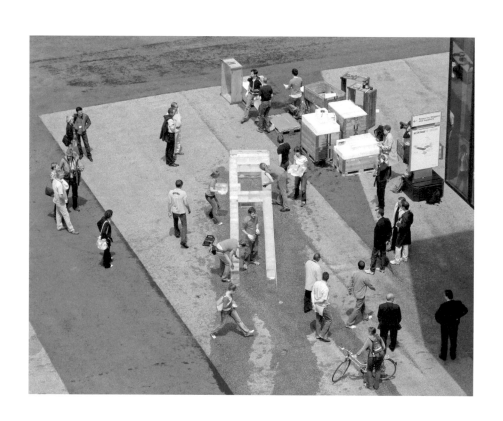

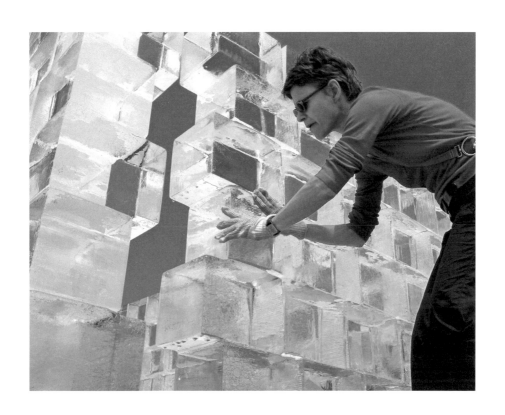

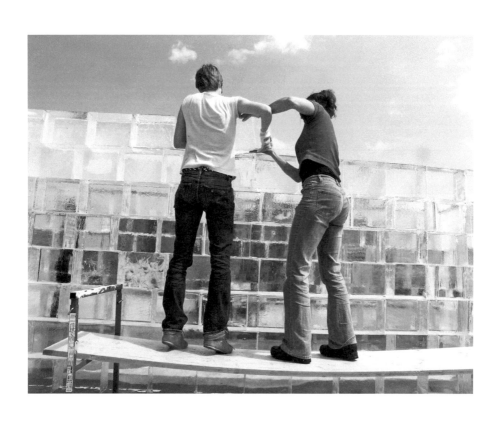

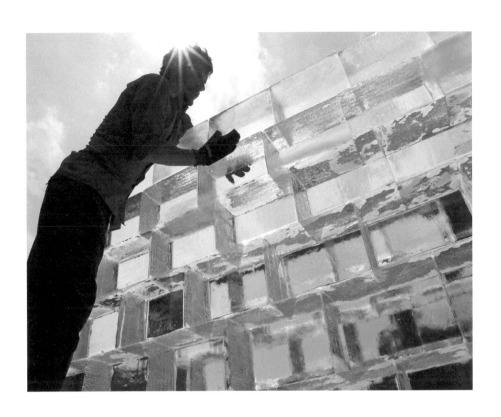

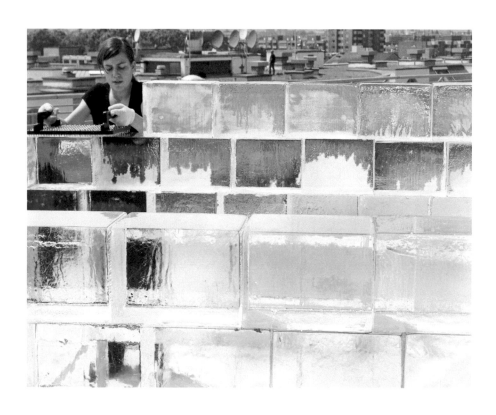

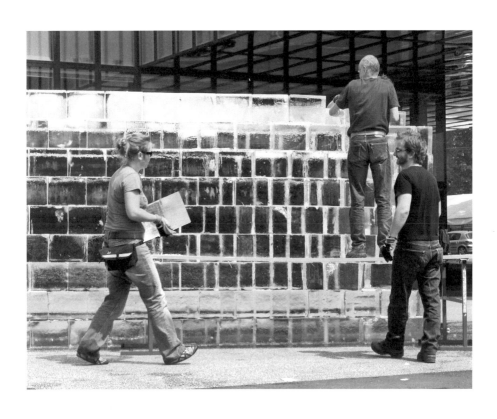

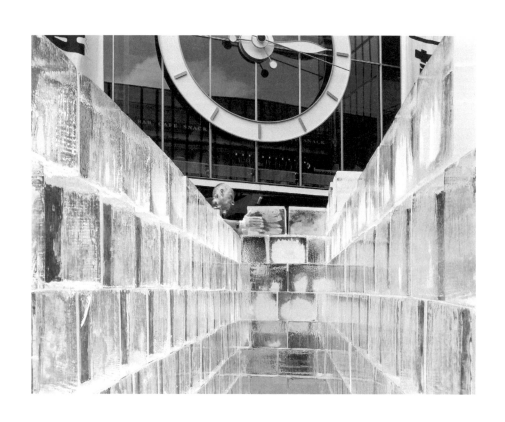

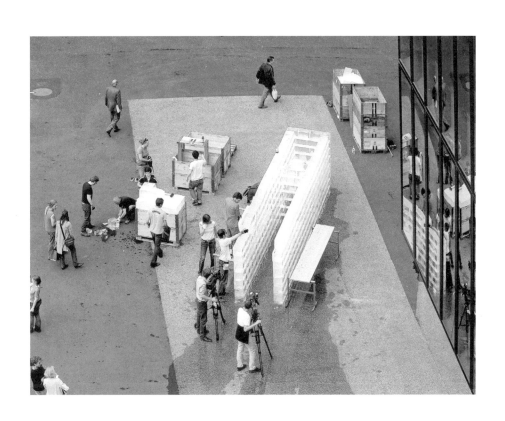

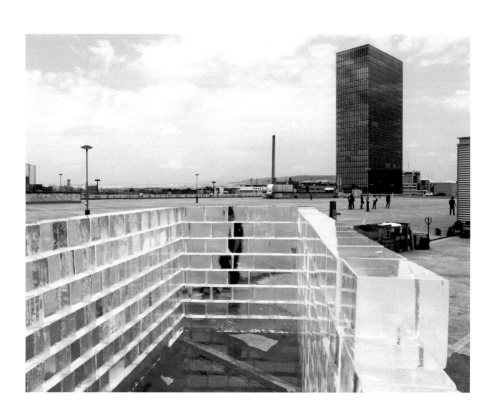

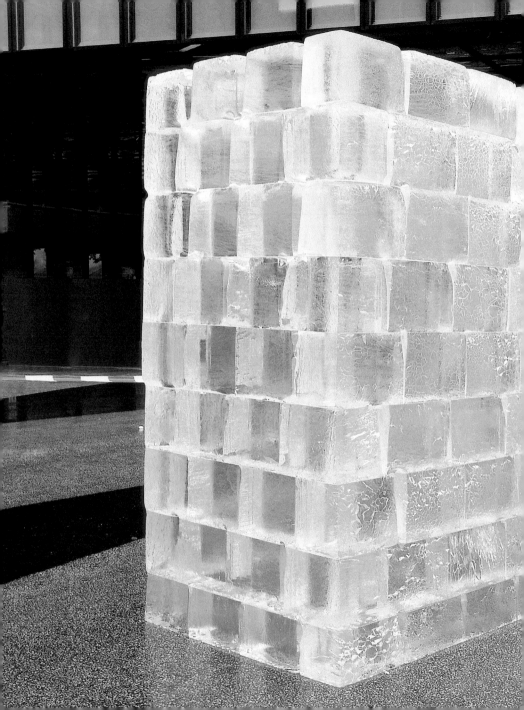

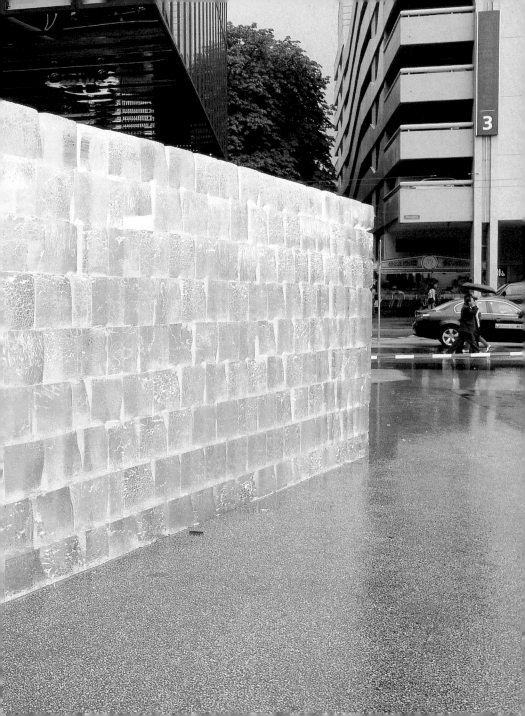

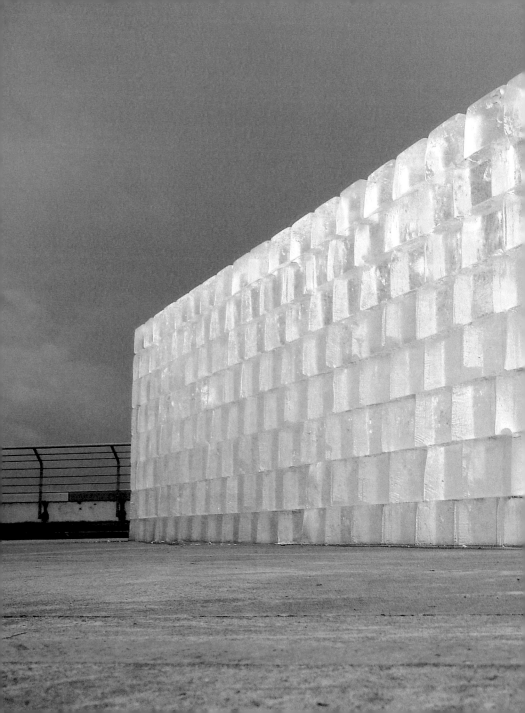

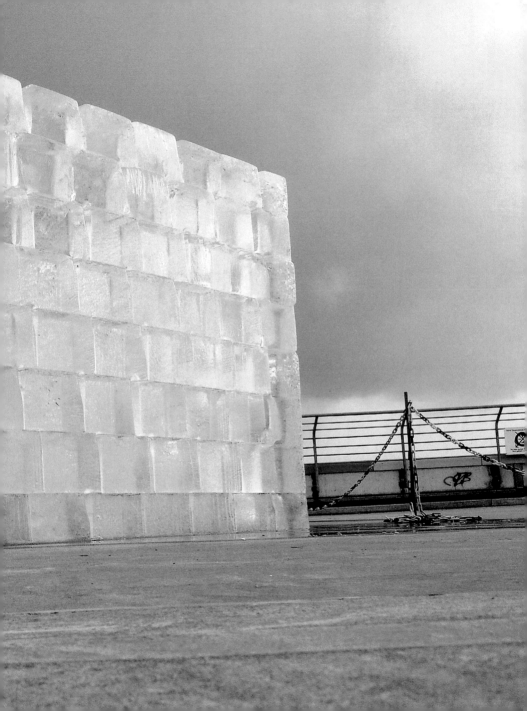

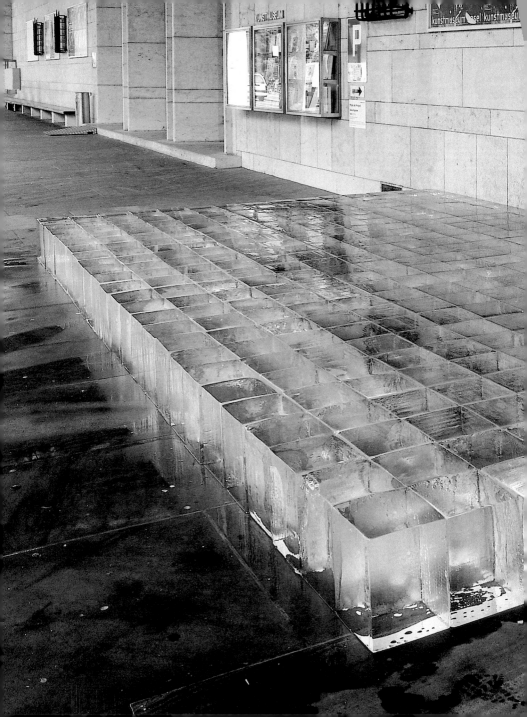

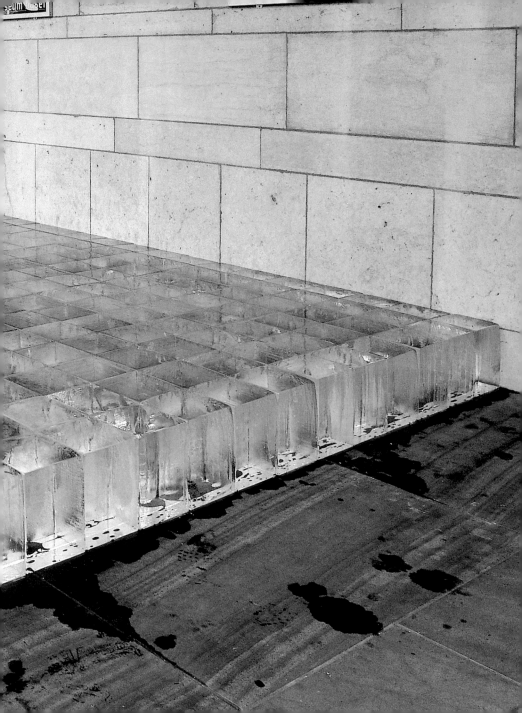

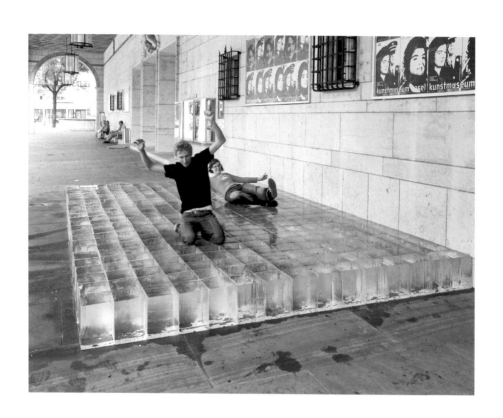

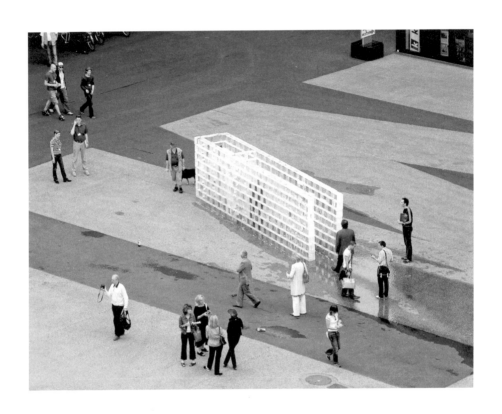

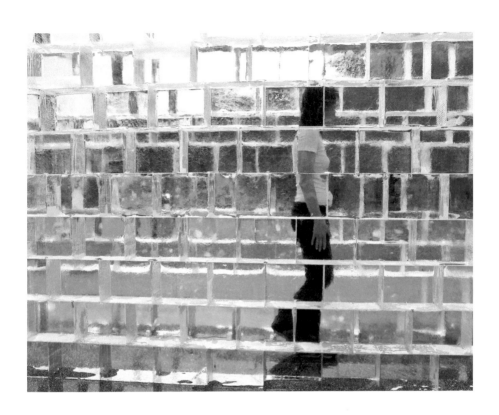

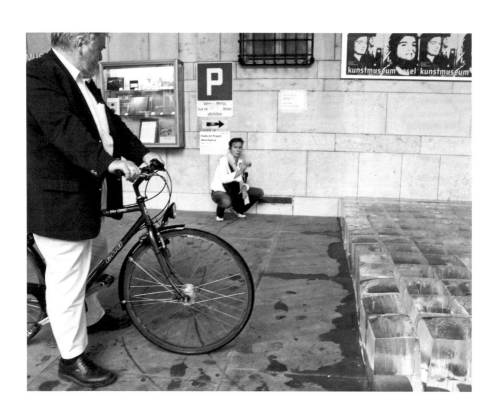

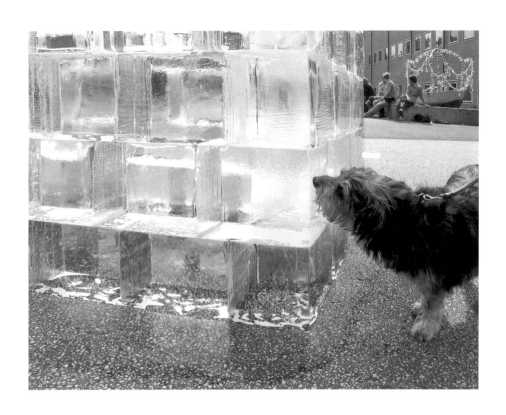

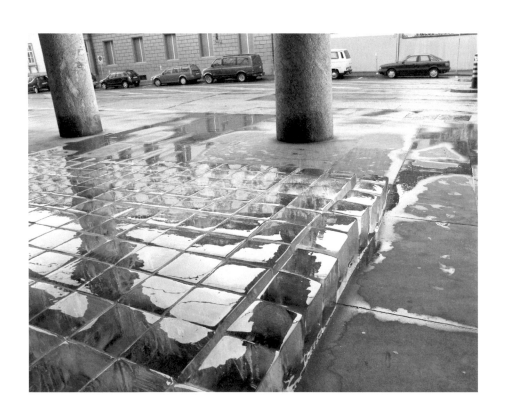

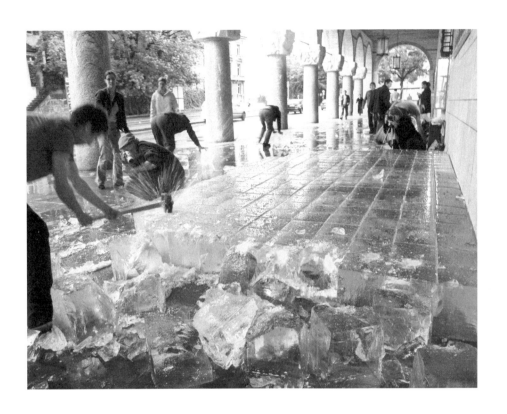

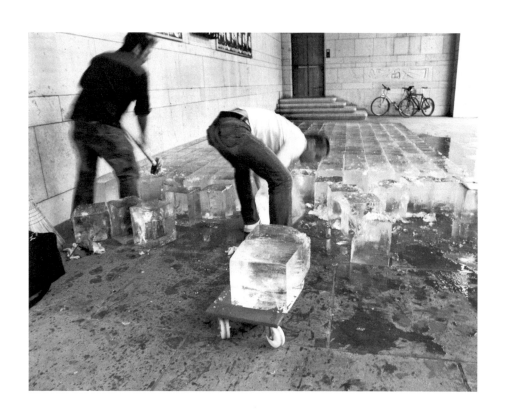

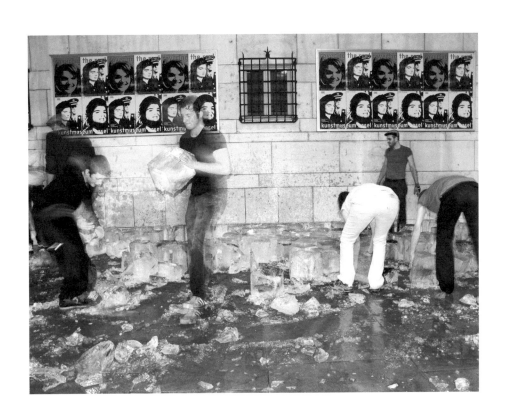

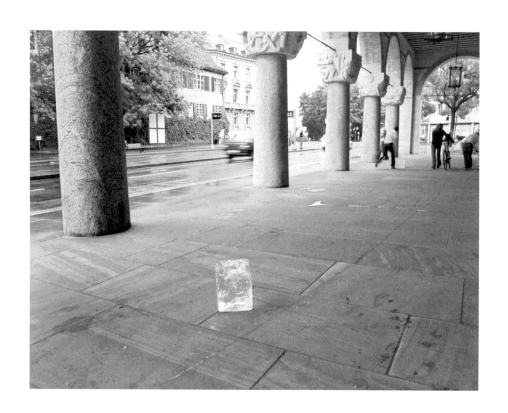

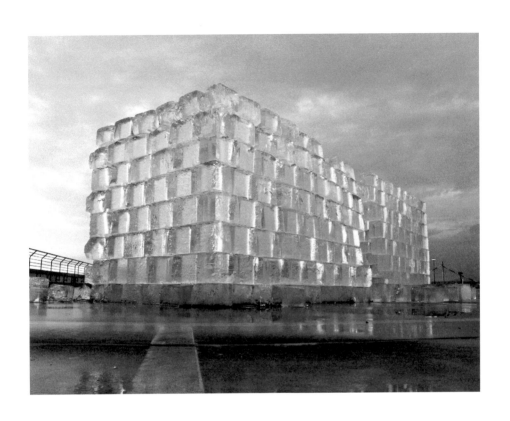

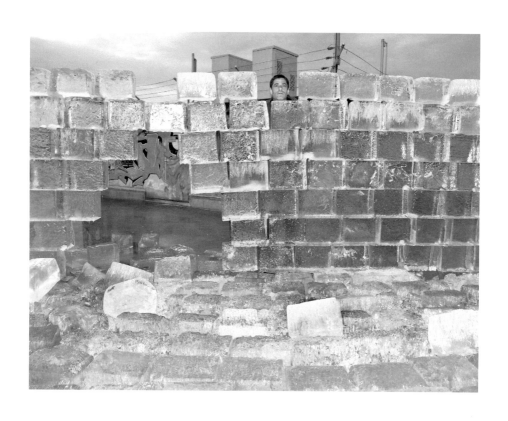

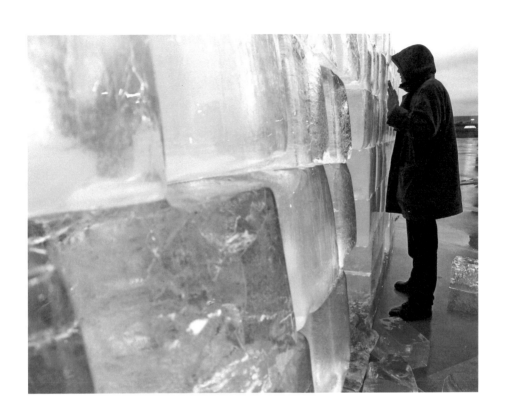

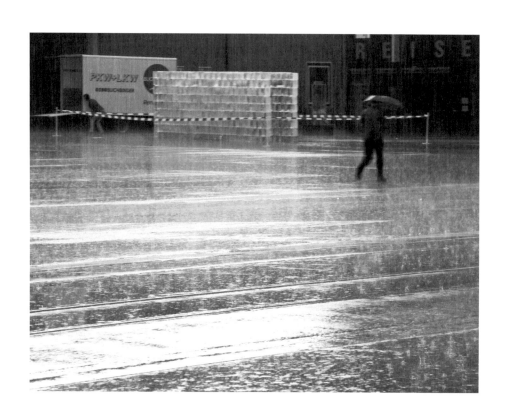

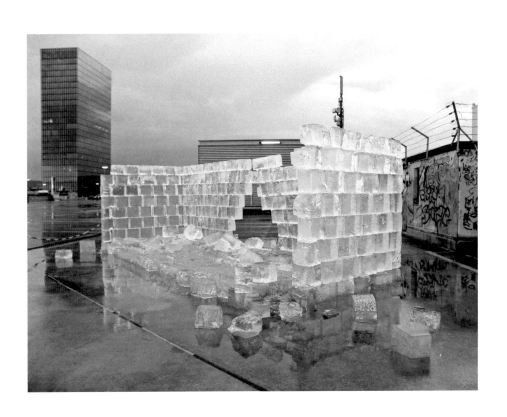

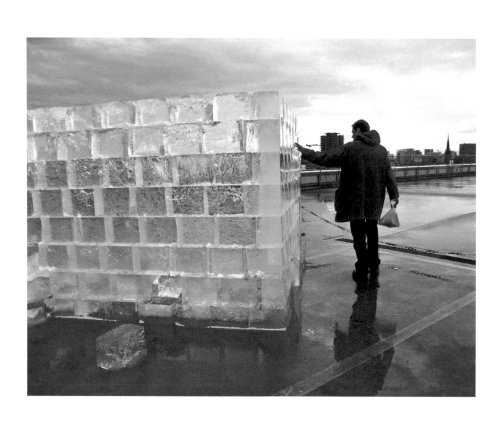

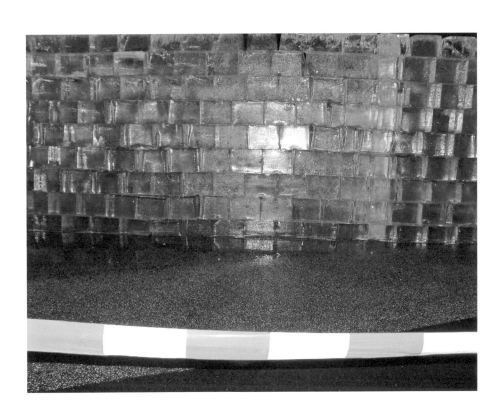

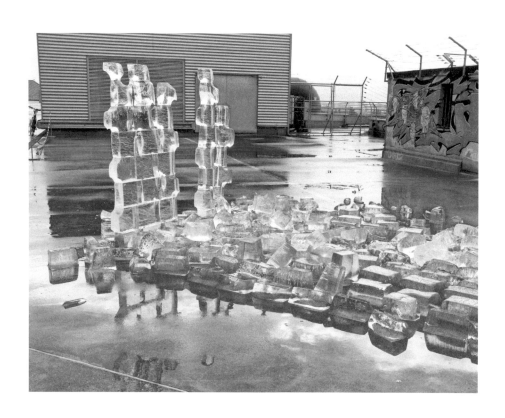

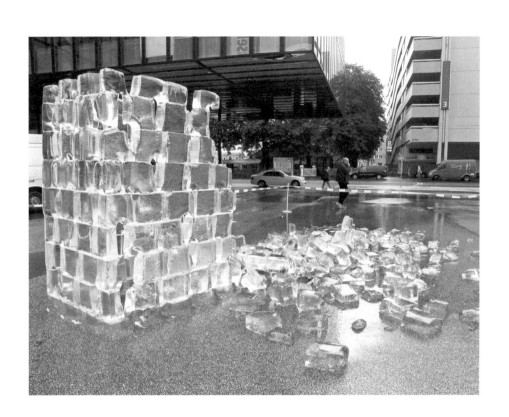

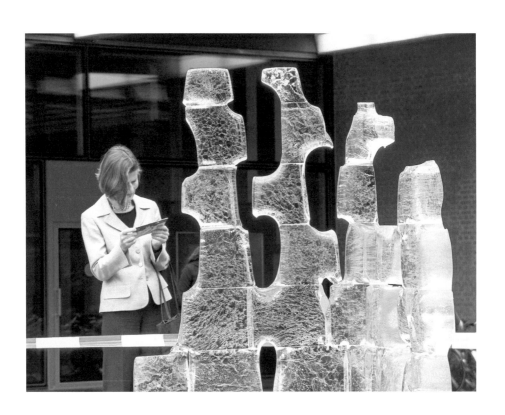

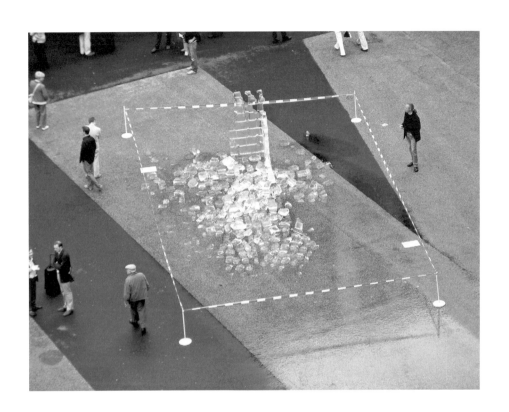

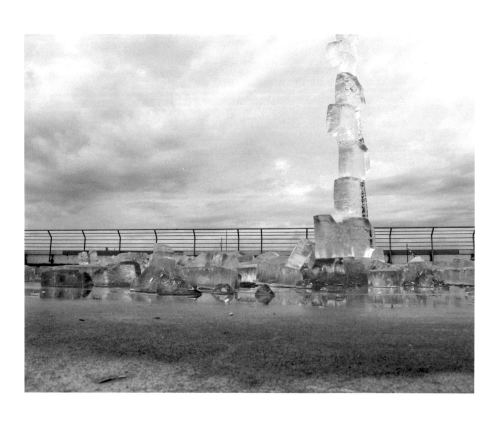

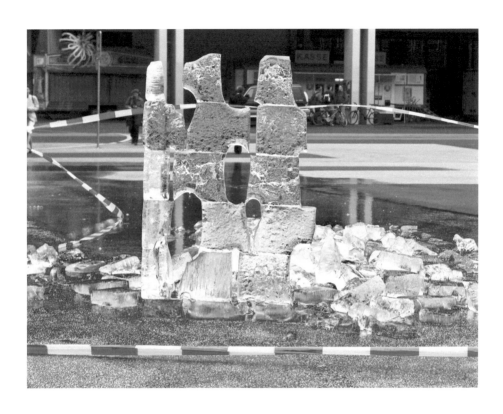

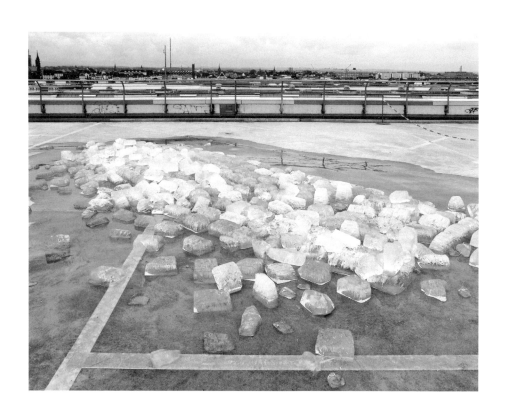

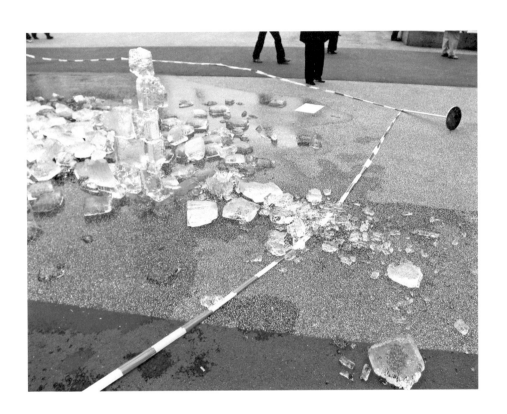

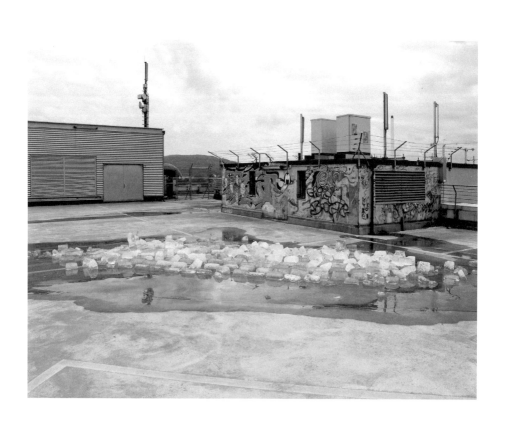

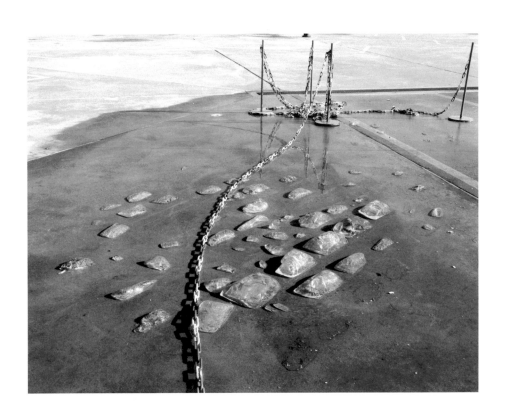

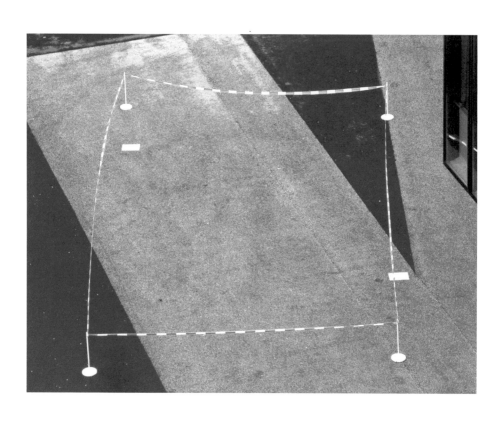

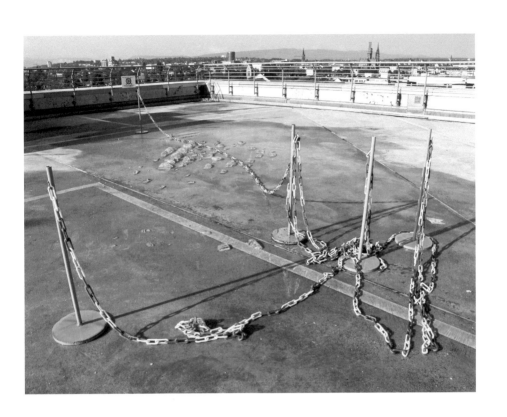

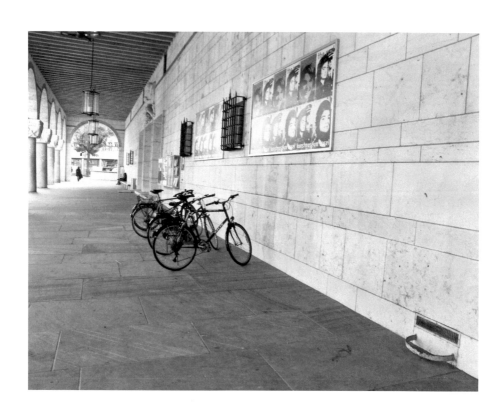

Fluids **2005 was realized by University of Art and Design HGK Basel, Basel University, and Hauser & Wirth Zürich London. The following people have been involved:**

Stefan Altenburger, Nino Baumgartner, Laura Bechter, Silvia Bergmann, Omar Blangiardi, Rebecca Bornhauser, Coryl Crane, Patricia da Rugna, Pawel Ferus, Nicolas Feldmeyer, Hartwig Fischer, Anna Goetz, Franziska Glozer, Andy Gröbli, Thomas Gunzenhauser, Gregor Hoffmann, Karin Hueber, Jann Jenatsch, Allan Kaprow, Roman Kurzmeyer, Mohéna Kuehni, Silvana Lannetta, David Lörtscher, Matej Modrinjak, Annina Matter, Yvonne Motzer, Christian Mueller, Maja Naef, Stefan Neuner, Kelly Nipper, Hanspeter Odermatt, Fredi Odermatt, René Pulfer, Sandra Ryf, Corina Schwingruber, Evelin Schüep, Stefanie Schüpbach, Erhard Siegrist, Daniel Spehr, Andy Spichty, Jürg Stäuble, Eva Theiler, Daniel Tischer, Judith Waelti, Armin B. Wagner, Hans-Jörg Walter, Käthe Walser, Martina Weber, Niklaus Wenger, Barbara Wimmer, Sämi Wüest, Bettina Zimmermann

Editor: Hauser & Wirth Zürich London **Coordination:** Laura Bechter
Photography: A. Burger, Zürich / Walter & Spehr, Basel / Jürg Stäuble, Basel
Concept & Design: FLAG, Zürich & P. Herrmann
Printing: Odermatt AG, Dallenwil **Bookbinding:** Schumacher AG, Schmitten
Special thanks to: Keystone Switzerland, Kelly Nipper, René Pulfer

2005 © Allan Kaprow, Hauser & Wirth Zürich London
and Verlag der Buchhandlung Walther König, Köln

Published by: Verlag der Buchhandlung Walther König, Köln Ehrenstr. 4, 50672 Köln
Tel. +49 (0) 221 / 20 59 6-53 Email: verlag@buchhandlung-walther-koenig.de

Die Deutsche Bibliothek CIP-Einheitsaufnahme
Ein Titelsatz für diese Publikation ist bei Der Deutschen Bibliothek erhältlich

Printed in Switzerland

Distribution outside Europe: D.A.P./Distributed Art Publishers, Inc., New York
155 Sixth Avenue, New York, NY 10013 Tel. 212-627-1999 Fax 212-627-9484

ISBN 3-88375-996-1